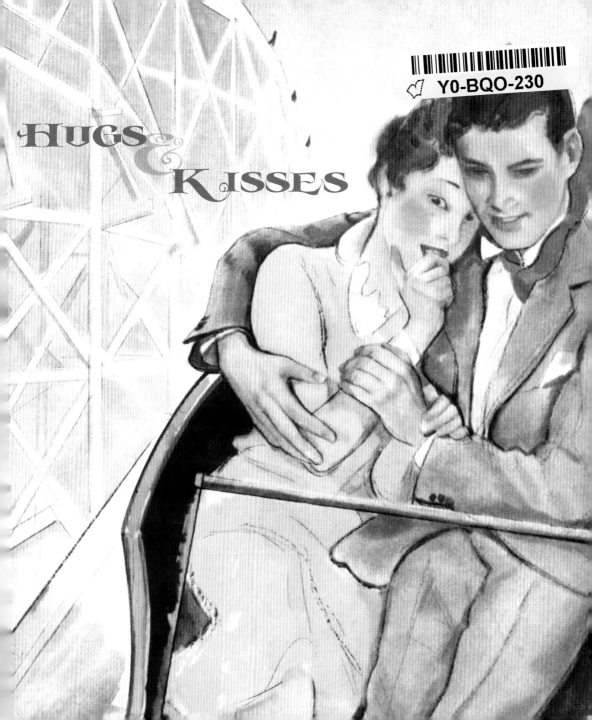

# HUGS & KISSES

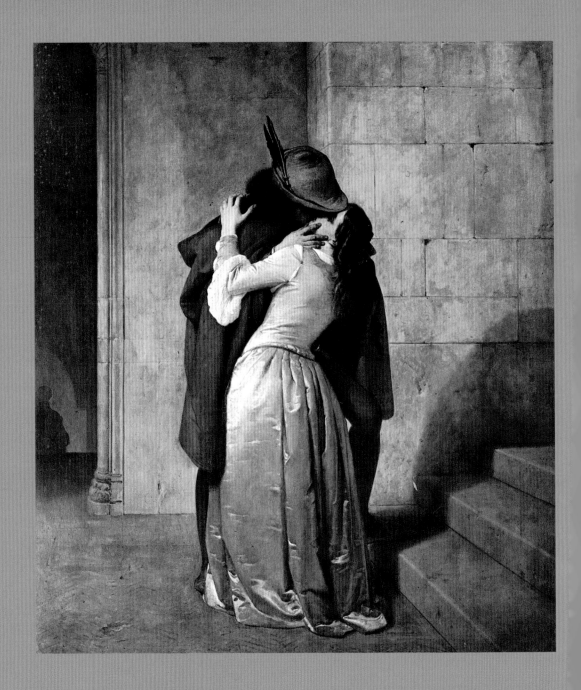

# HUGS & KISSES

COMPILED BY

## WELLERAN POLTARNEES

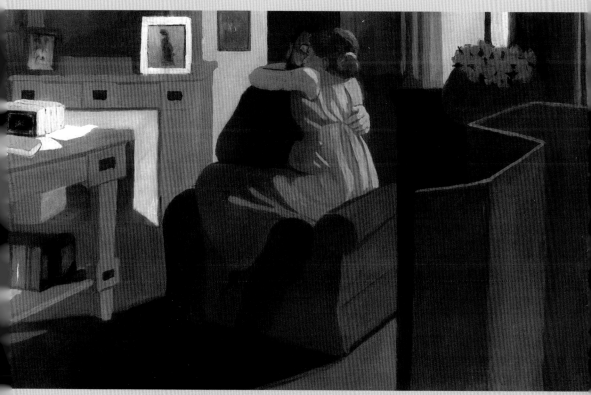

LAUGHING ELEPHANT · MMXI

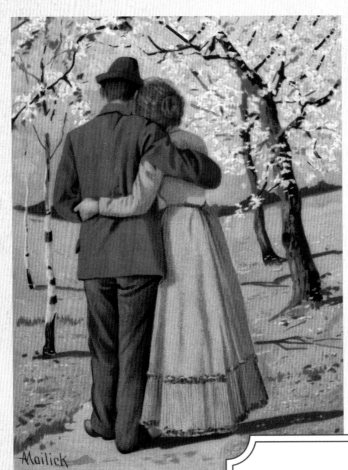

So, when I love, the first afire
Is body with its quick desire;
Then in a little while I find
The flame has crept into my mind—
Till steadily, sweetly burns the whole
Bright conflagration of my soul.

JAN STRUTHER

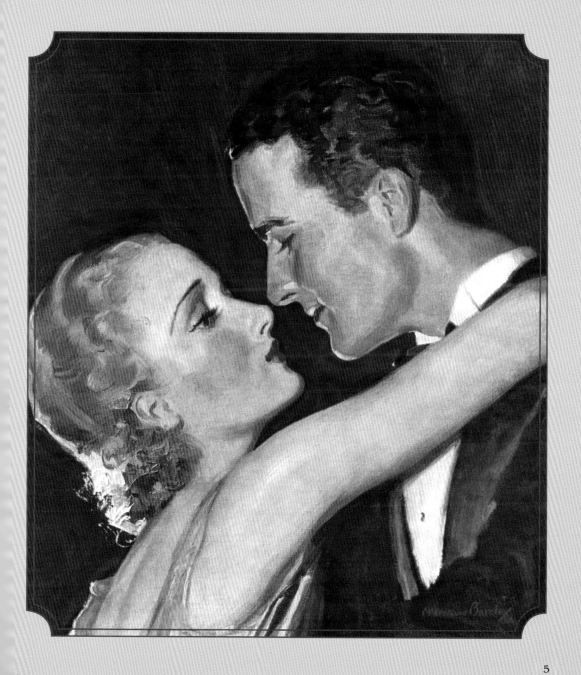

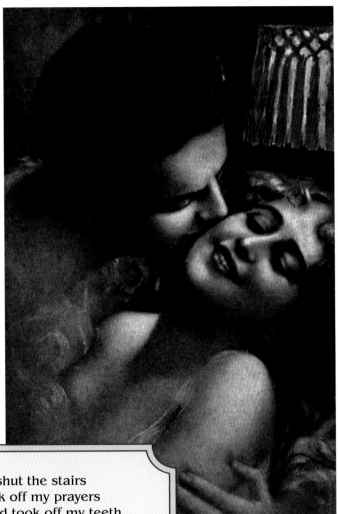

I climbed the door and shut the stairs
I said my shoes and took off my prayers
I brushed my clothes and took off my teeth
I pulled down my alarm and set my sheets
I shut off my bed and I climbed into my light
And all because she kissed me goodnight

FROM AN OLD PHOTOGRAPH ALBUM

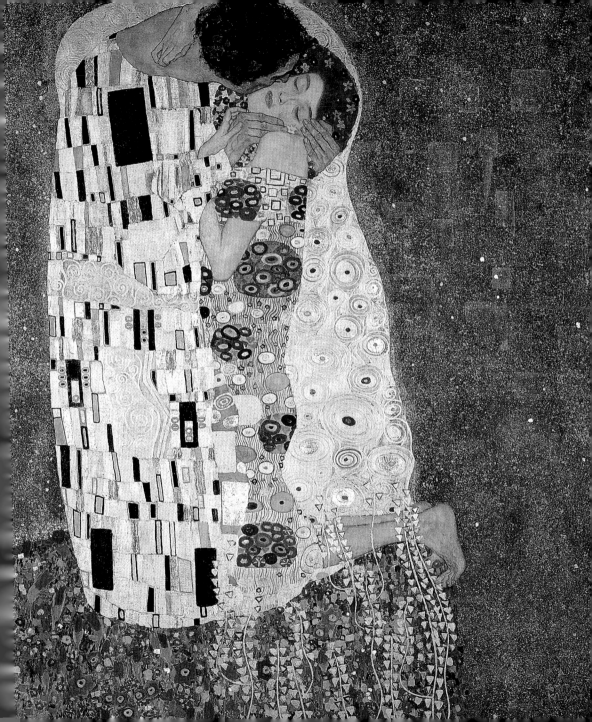

To drink her lips is like sipping
Essence of Eternity.

SOUTH INDIAN VERSE

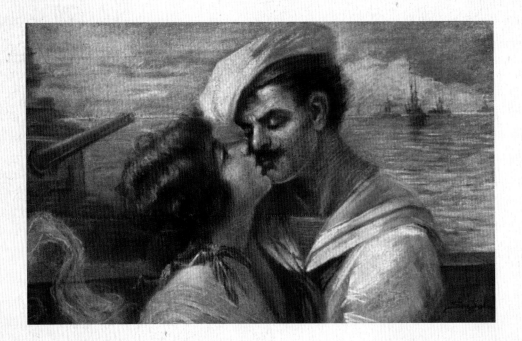

Kissing is a means of getting two people so
close together that they can't see anything
wrong with each other.

RENÉ YASENEK

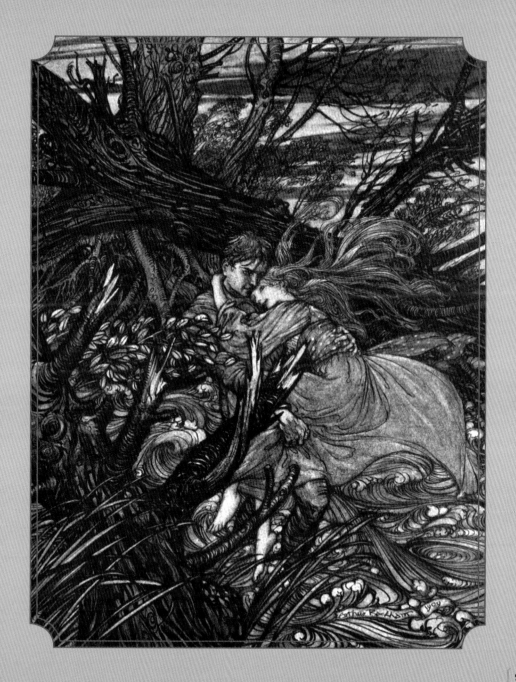

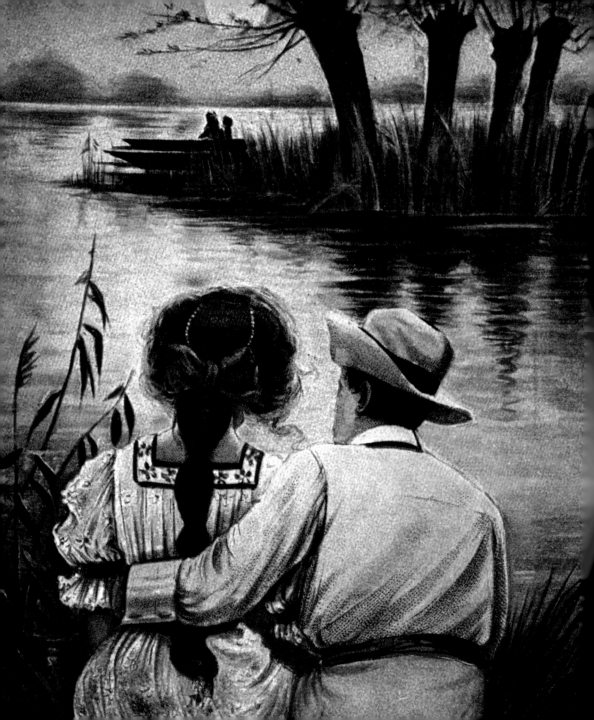

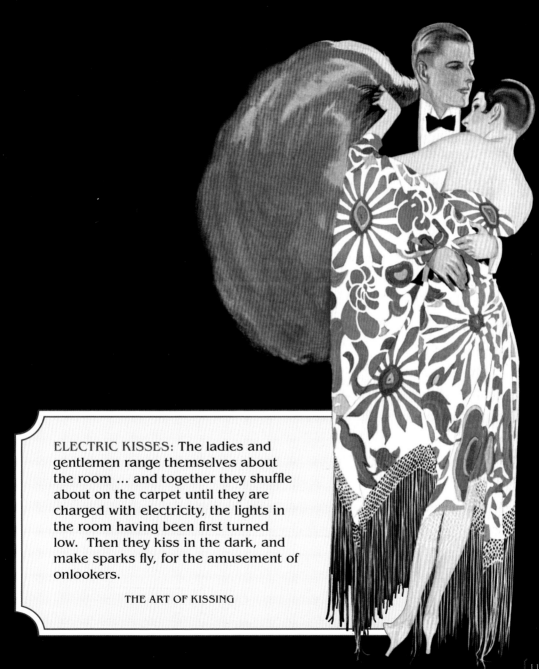

ELECTRIC KISSES: The ladies and gentlemen range themselves about the room … and together they shuffle about on the carpet until they are charged with electricity, the lights in the room having been first turned low.  Then they kiss in the dark, and make sparks fly, for the amusement of onlookers.

THE ART OF KISSING

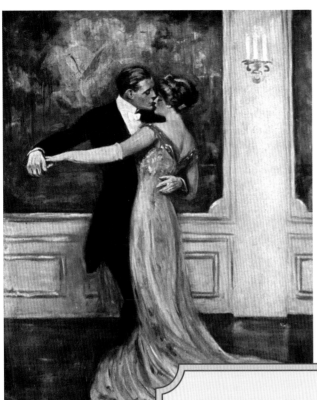

And what is a kiss, when all is done?
A promise given under a seal — a vow
Taken before the shrine of memory
A signature acknowledged — a rosy dot
Over the i of Loving — a secret whispered
To listening lips apart — a moment made
Immortal, with a rush of wings unseen —
A sacrament of blossoms, a new song
Sung by two hearts to an old simple tune —
The ring of one horizon around two souls
Together, all alone!

EDMOND ROSTAND

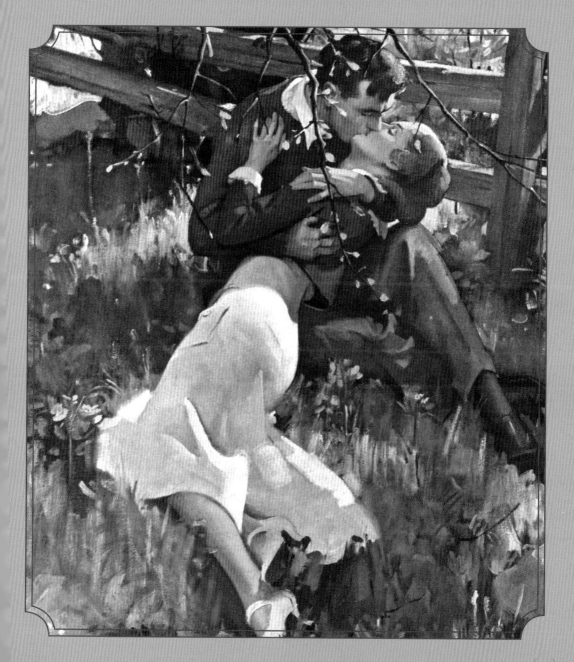

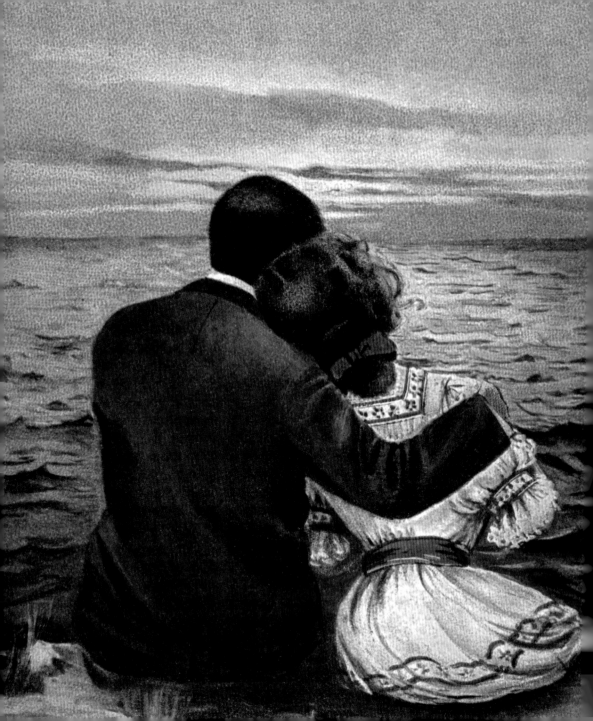

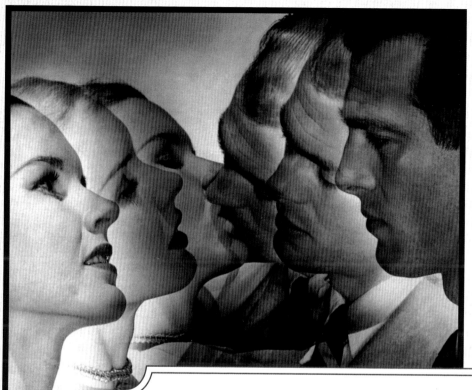

Although the mouth be a parcel of the body, yet is it an issue for the words that be the interpreters of the soul, and for the inward breath, which is also called the soul; and therefore hath a delight to join his mouth with the woman's beloved with a kiss—not to stir him to any unhonest desire, but because he feeleth that that bond is the opening of an entry to the souls, which, drawn with a coveting the one of the other, pour themselves by turn the one into the other's body, and be so mingled together that each of them hath two souls.

BALDASSARE CASTIGLIONE

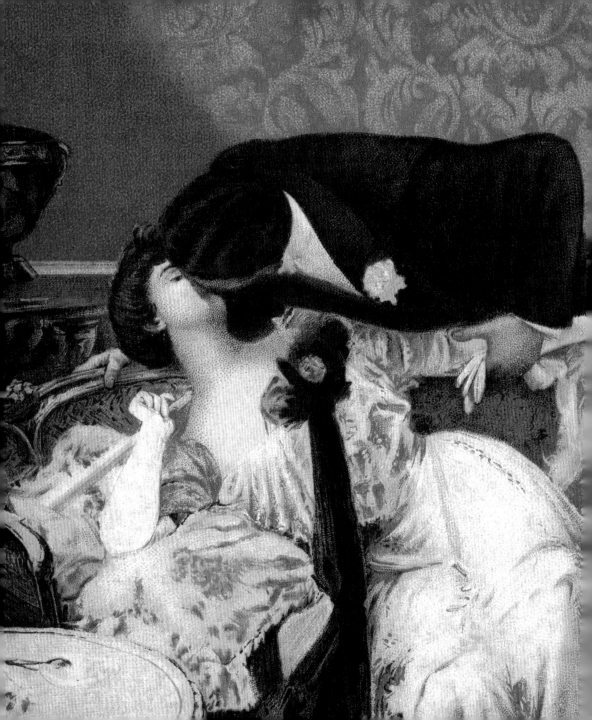

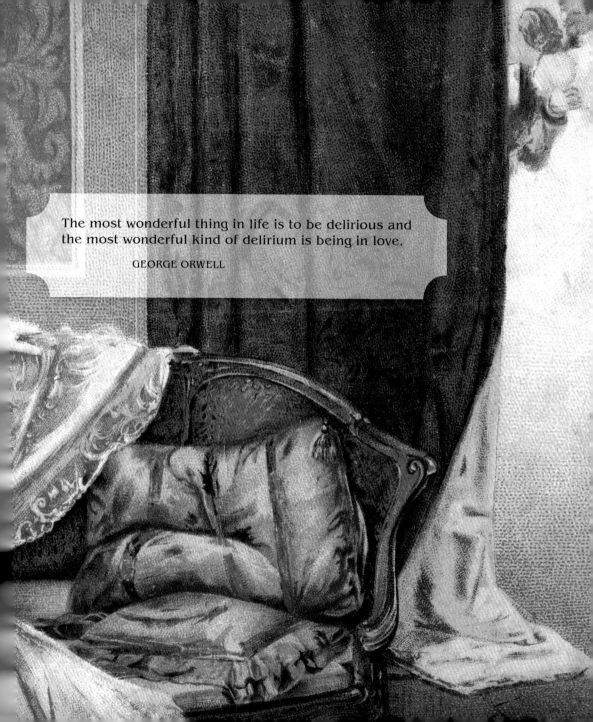

The most wonderful thing in life is to be delirious and the most wonderful kind of delirium is being in love.

GEORGE ORWELL

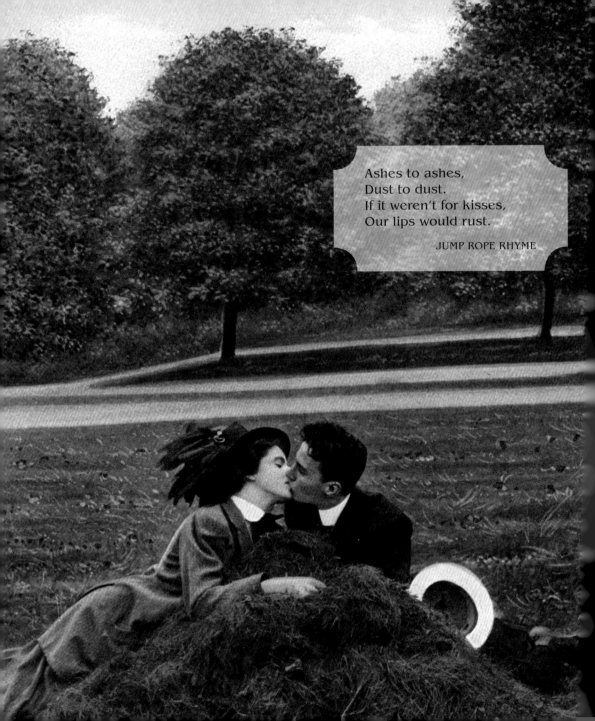

Ashes to ashes,
Dust to dust.
If it weren't for kisses,
Our lips would rust.

JUMP ROPE RHYME

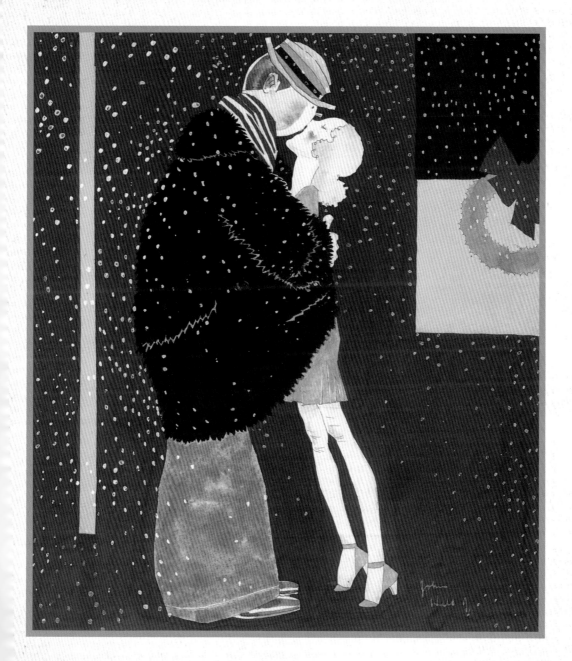

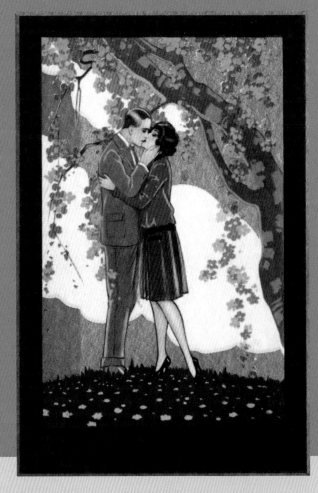

A kiss is: It is the hug without which the kiss means nothing.

GELLETT BURGESS

A kiss is: A contraction of the heart due to an enlargement of the heart.

ANONYMOUS

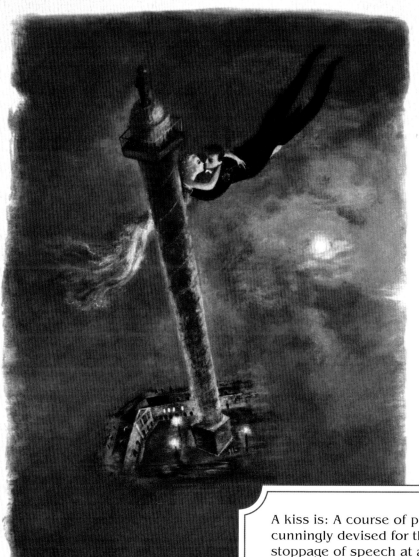

A kiss is: A course of procedure, cunningly devised for the mutual stoppage of speech at a moment when words are superfluous.

OLIVER HERFORD

But a kiss fairly electrifies you, it warms your blood and sets your heart a beatin' like a brass drum, and makes your eyes twinkle like stars in a frosty night. It isn't a thing ever to be forgot. No language can express it, no letters will give the sound.... It is neither visible, nor tangible, nor portable, nor transferable. It is not a substance, nor a liquid, nor a vapour. It has neither colour nor form. Imagination can't conceive it. It can't be imitated or forged. It is confined to no clime or country, but is ubiquitous. It is disembodied when completed, but is instantly reproduced, and so is immortal. It is as old as the creation, and yet is as young and fresh as ever.... It pervades all nature. The breeze as it passes kisses the rose, and the pendant vine stoops down and hides with its tendrils its blushes, as it kisses the limpid stream that waits in an eddy to meet it, and raises its tiny waves, like anxious lips to receive it. Depend upon it. Eve learned it in Paradise, and was taught its beauties, virtues, and varieties by an angel, there is something so transcendent in it.

THOMAS C. HALIBURTON

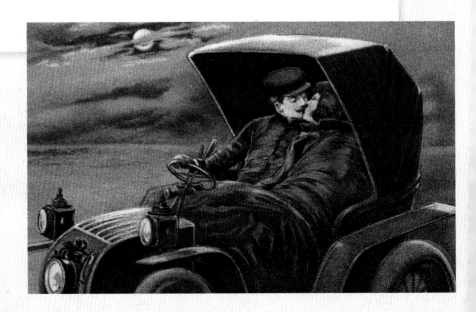

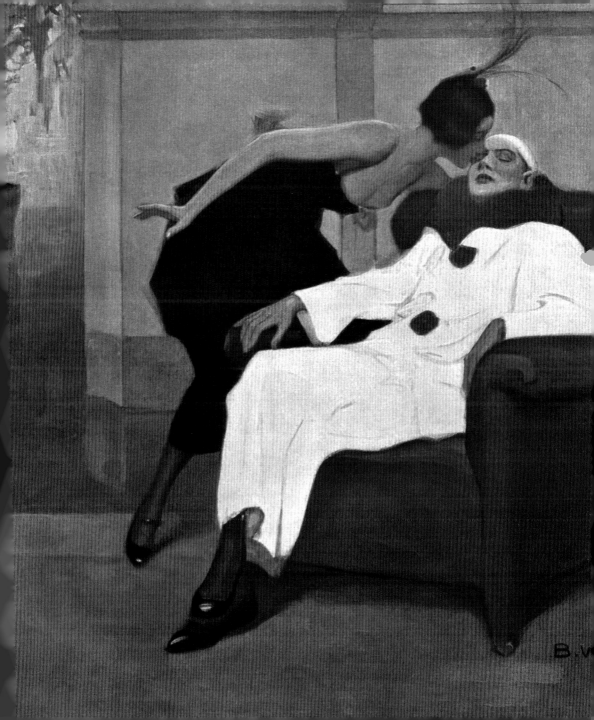

"Kiss" rhymes with "Bliss"
in fact as well as verse.

LORD BRYON.

I twist your arm,
You twist my leg,
I make you cry,
You make me beg,
I dry your eyes,
You wipe my nose,
And that's the way
The kissing goes.

WILLIAM WOOD

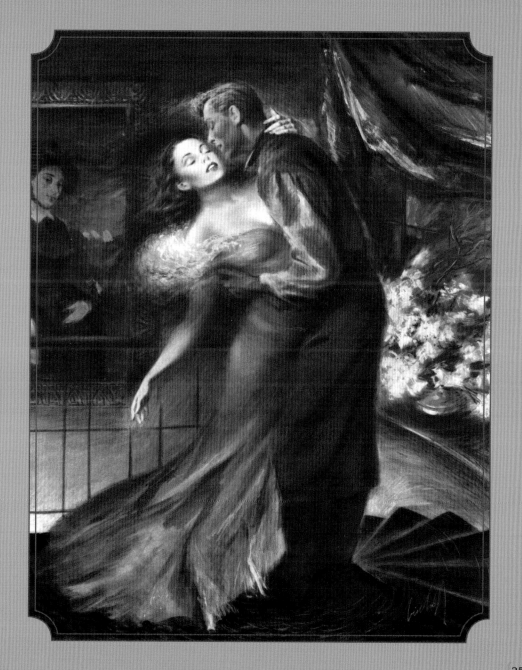

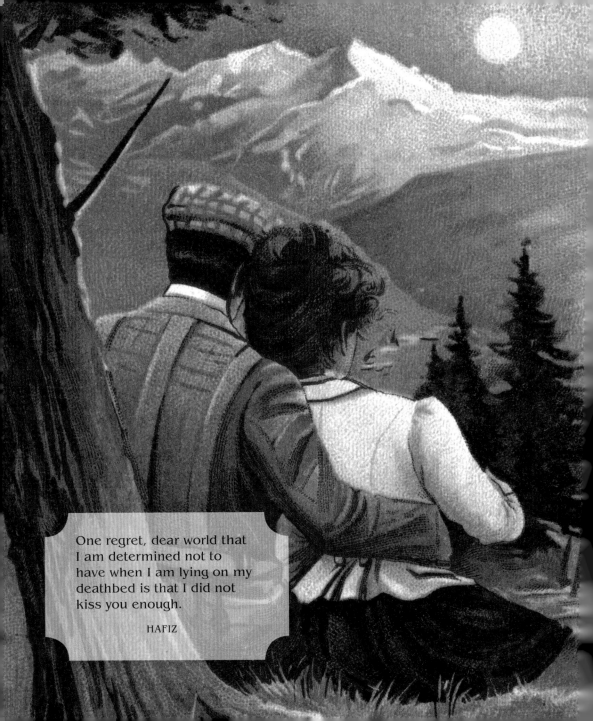

One regret, dear world that
I am determined not to
have when I am lying on my
deathbed is that I did not
kiss you enough.

HAFIZ

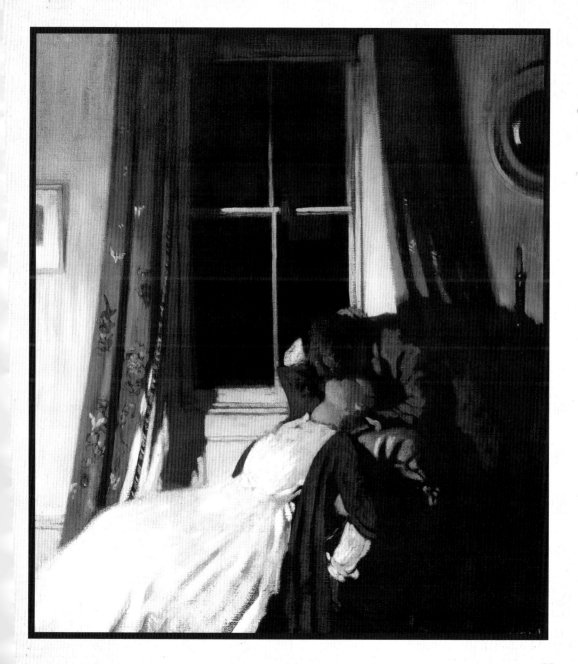

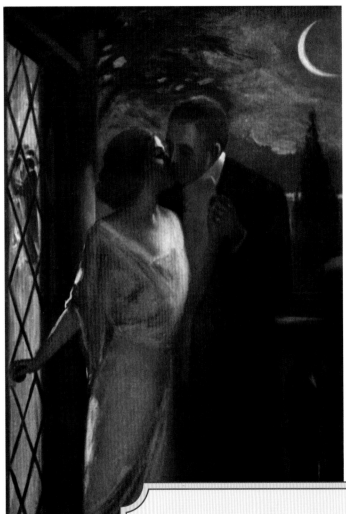

A kiss seems like the smallest movement of the lips, yet it can capture emotions wild as kindling, or be a contract, or dash a mystery.

DIANE ACKERMAN

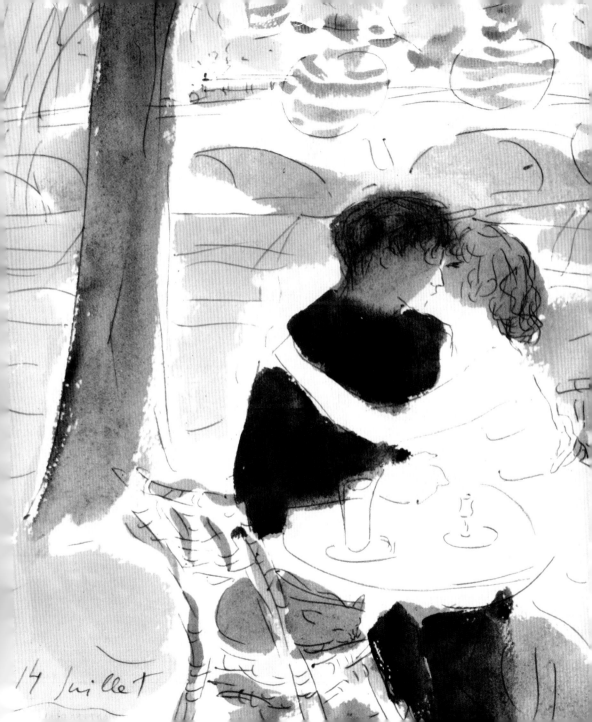

14 Juillet

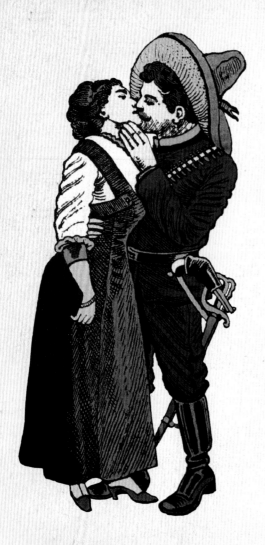

ISBN  978-1-59583-431-7

LAUGHING ELEPHANT LAUGHINGELEPHANT.COM

# PICTURE CREDITS

| | |
|---|---|
| Cover | Anton Otto Fischer. Book cover, c. 1915. |
| Half-title | Phoebe Traquair. Book illustration, 1896. |
| Frontispiece | Francesco Hayez. "The Kiss," 1859. |
| Title Page | Félix Vallotton. "Intimacy," 1898. |
| 4 | Alfred Mailick. Postcard, n.d. |
| 5 | McLelland Barclay. Magazine cover, 1932. |
| 6 | Unknown. Postcard, n.d. |
| 7 | Gustav Klimt. "The Kiss," (detail) 1907. |
| 8 | Unknown. Postcard, n.d. |
| 9 | Arthur Rackham. From *Undine*, 1909. |
| 10 | Unknown. Postcard, c. 1908. |
| 11 | John Holmgren. Magazine cover, 1926. |
| 12 | Unknown. Postcard, n.d. |
| 13 | C.E. Chambers. Magazine illustration, 1937. |
| 14 | Unknown. Postcard, n.d. |
| 15 | Ralph Bartholomew Jr. Photograph, c. 1940. |
| 16-17 | Unknown. Postcard, n.d. |
| 18 | Unknown. Postcard, n.d. |
| 19 | John Held Jr. Illustration, n.d. |
| 20 | Unknown. Postcard, n.d. |
| 21 | Unknown. Advertising illustration, n.d. |
| 22 | Unknown. Postcard, n.d. |
| 23 | B. Wennerberg. "Glück im Winkel," c. 1920. |
| 24 | Unknown. Postcard, n.d. |
| 25 | Herman E. Bischoff. Magazine illustration, 1946. |
| 26 | Unknown. Postcard, n.d. |
| 27 | William Orpen. "Night," 1907. |
| 28 | Unknown. Postcard, n.d. |
| 29 | Marcel Vertés. Illustration, c. 1955. |
| 30 | J.G. Posada. "La Despedida," n.d. |
| 32 | A.H. Fish. From *Behind the Beyond*, 1913. |
| Back Cover | Rockwell Kent. From *Voyaging*, 1924. |

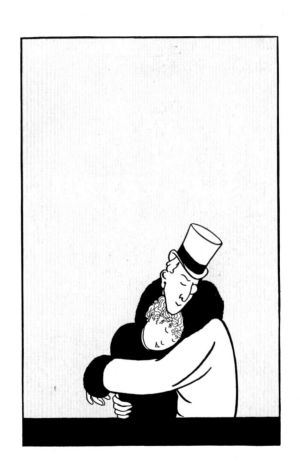